How to Draw

African Animals

In Simple Steps

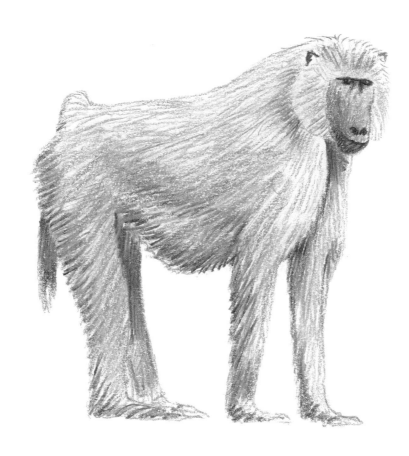

First published in 2021

Search Press Limited
Wellwood, North Farm Road,
Tunbridge Wells, Kent TN2 3DR

Reprinted 2023

ISBN: 978-1-78221-871-5

You are invited to visit the author's website:
www.jonathannewey.com

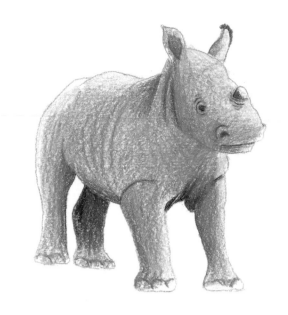

Dedication

*To my wife Charlotte, my family and friends and to
the wildlife of the world, you inspire me always.*

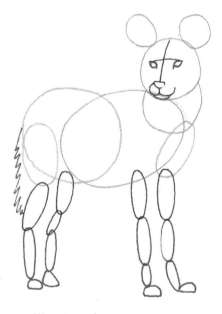

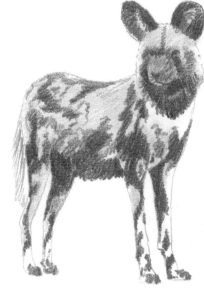

Illustrations

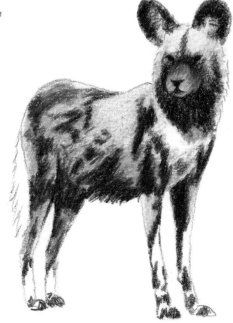

How to Draw
African Animals

In Simple Steps
Jonathan Newey

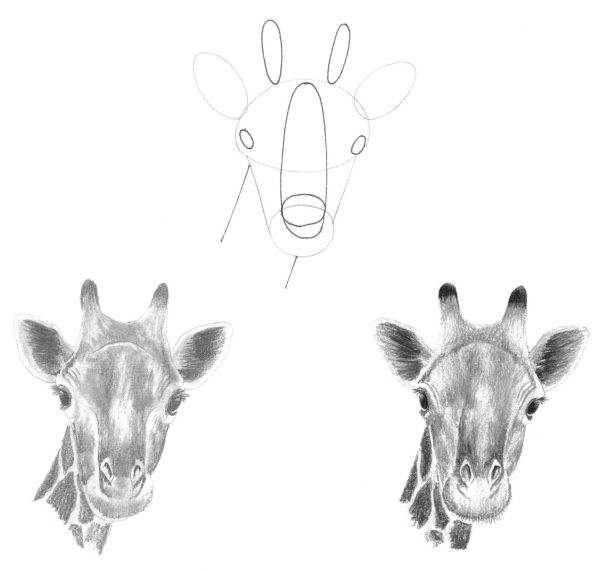

Search Press

Introduction

This book introduces you to drawing African animals. As well as the popular lion, elephant, rhinoceros and zebra, you will also find the lesser-known warthog, fish eagle and kudu. Using step-by-step techniques, I explain how to build up the shape and form of each animal using basic shapes and lines. I have included a variety of different mammals and birds in a mixture of poses, including head and shoulders and full body illustrations.

Each project begins with shapes drawn in pencil. New lines are added for each subsequent step. These have been drawn in brown pencil to separate them from the initial steps made with a graphite (lead) pencil, with the previous pencil lines left in as a guide. When using the brown pencil, make sure it is easily erased at the end of the drawing stages before starting the shading or colouring in.

At the bottom of each page are two finished illustrations: one drawn in graphite pencil and the other using coloured pencils. The black and white drawing shows the form and texture which is not easily seen when in colour. Once you have finished your initial drawing and are happy with the shapes and lines, you should complete your project with the medium of your choice. All of the initial line drawing stages can be used as a basis for most drawing and painting mediums.

Try out as many of the projects as possible and in a variety of different mediums. If you would prefer to draw from your own source material then you may want to use photographs for reference or do a picture of your pet if they can sit still long enough! Other sources for subjects are zoos and wildlife parks, or you might even be lucky enough to go on a safari! A visit to the local library or surfing the internet can provide you with further reference, but remember that if you want to use someone else's photographs to draw from you will need their permission otherwise you may be in breach of copyright laws.

To gain further knowledge and for more inspiration, look at the work of other artists. David Shepherd, Robert Bateman, Alan M. Hunt and Terry Isaac are a few of my favourites. Practise as much as you can. Once you have gained enough experience and knowledge with the exercises in this book, use as much time as possible to draw as many different types of animals as you can. Each animal is unique. Even males and females of the same species can look quite different, as can their young, for example the lion, lioness and lion cub. The step-by-step demonstrations shown here can be used whichever animal you decide to draw.

Finally, use this book to practise your observation skills. Drawing correctly is all about using your eyes; draw what you can see, not what you think is there. Above all else, enjoy yourself!

Happy drawing!

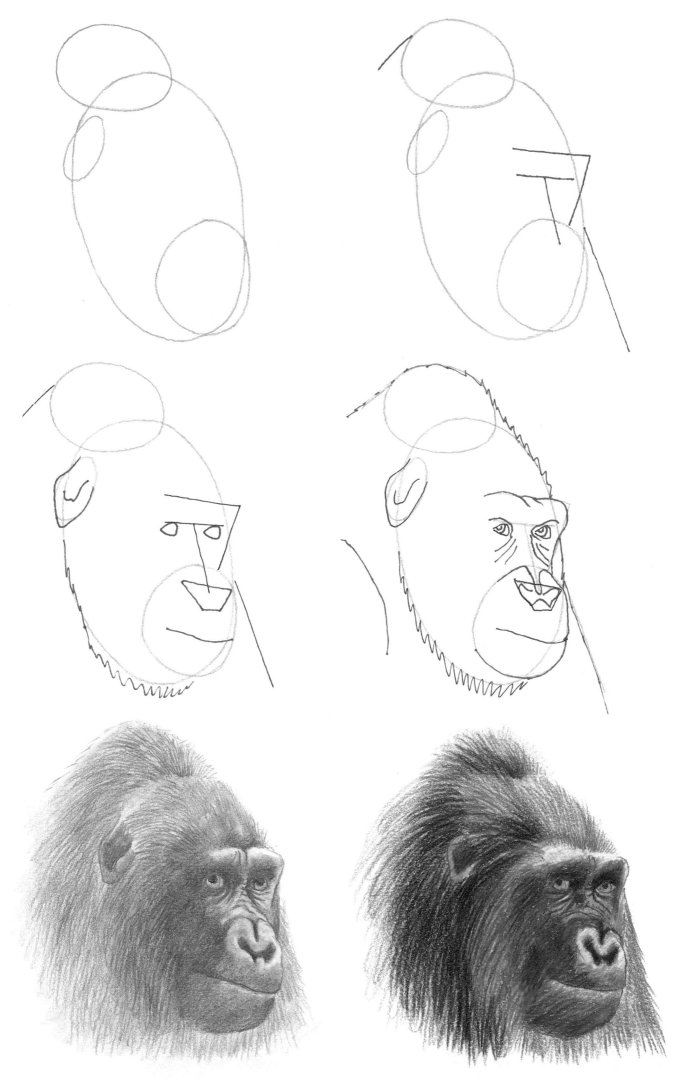

5

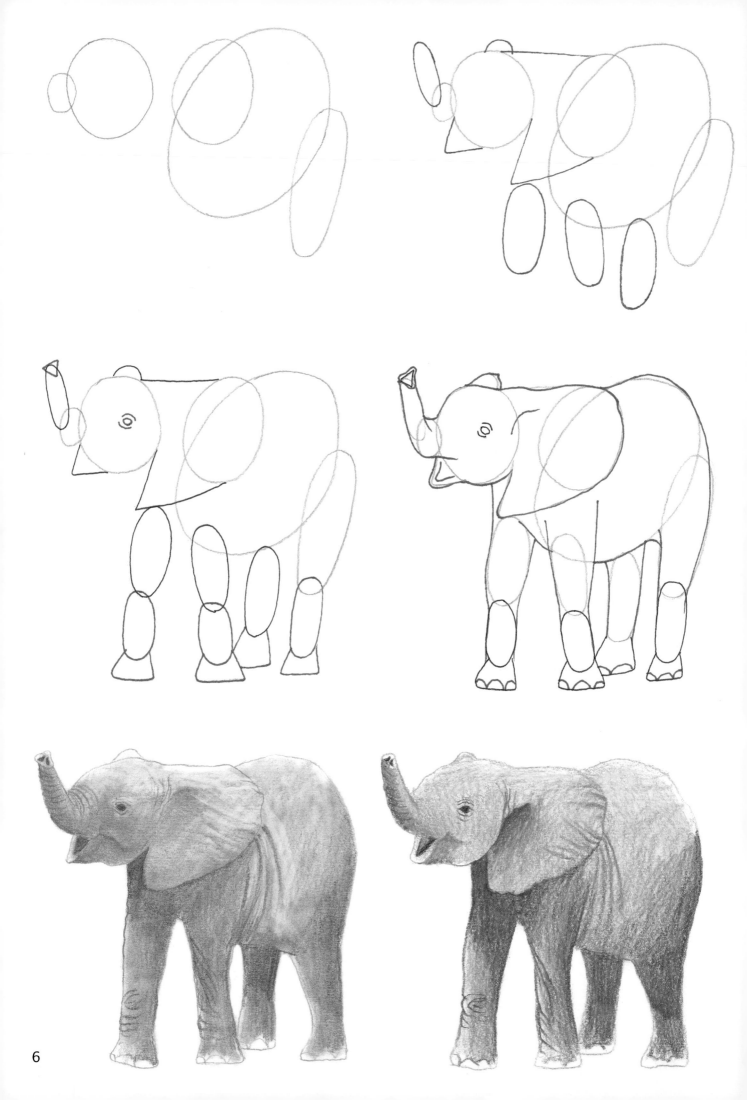

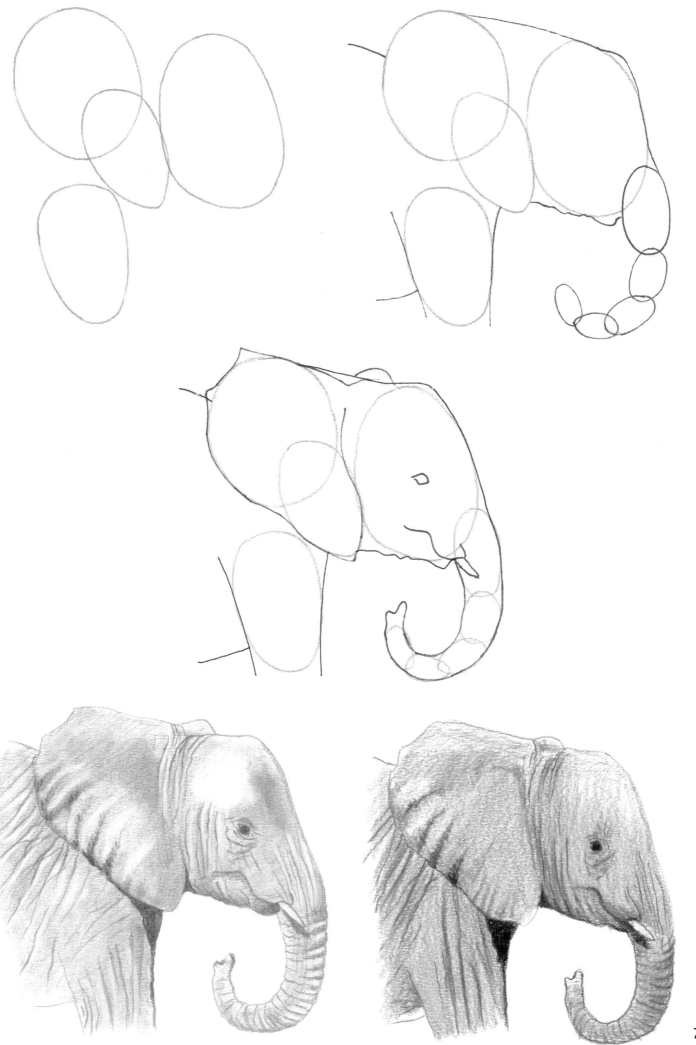

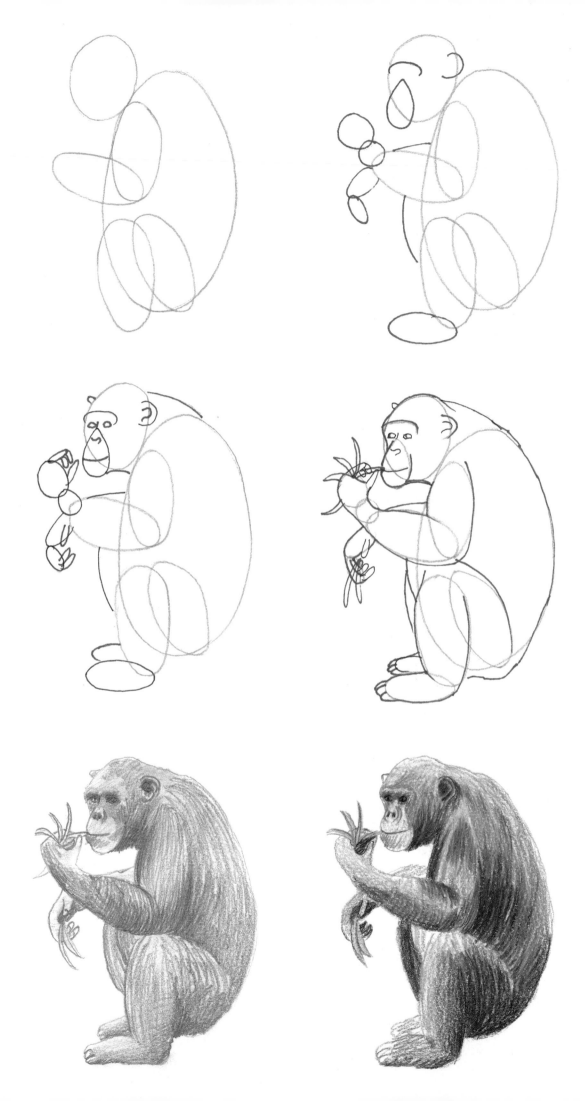

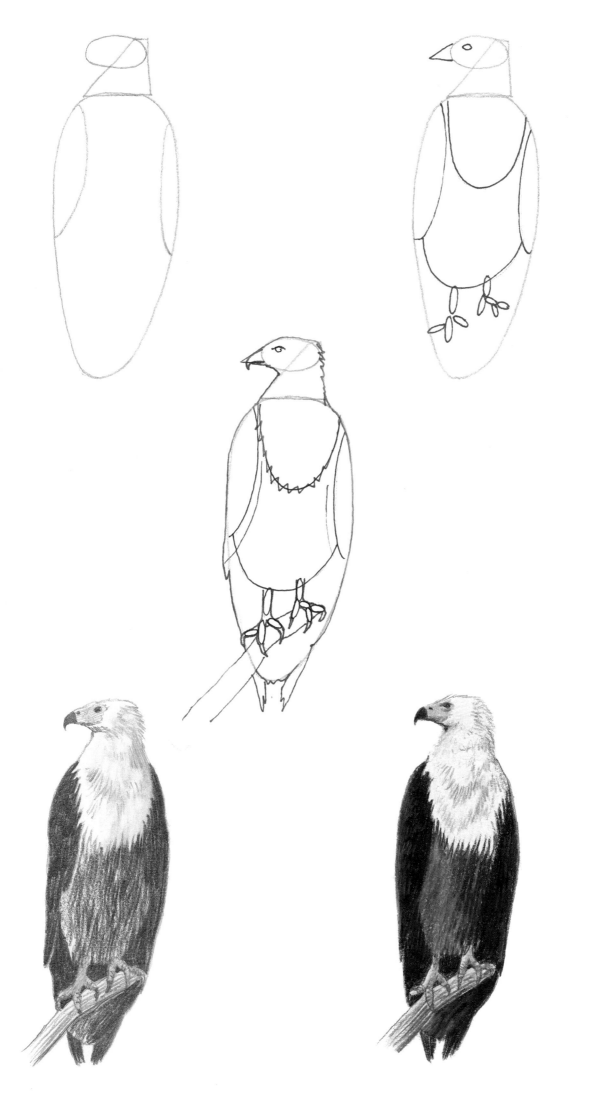

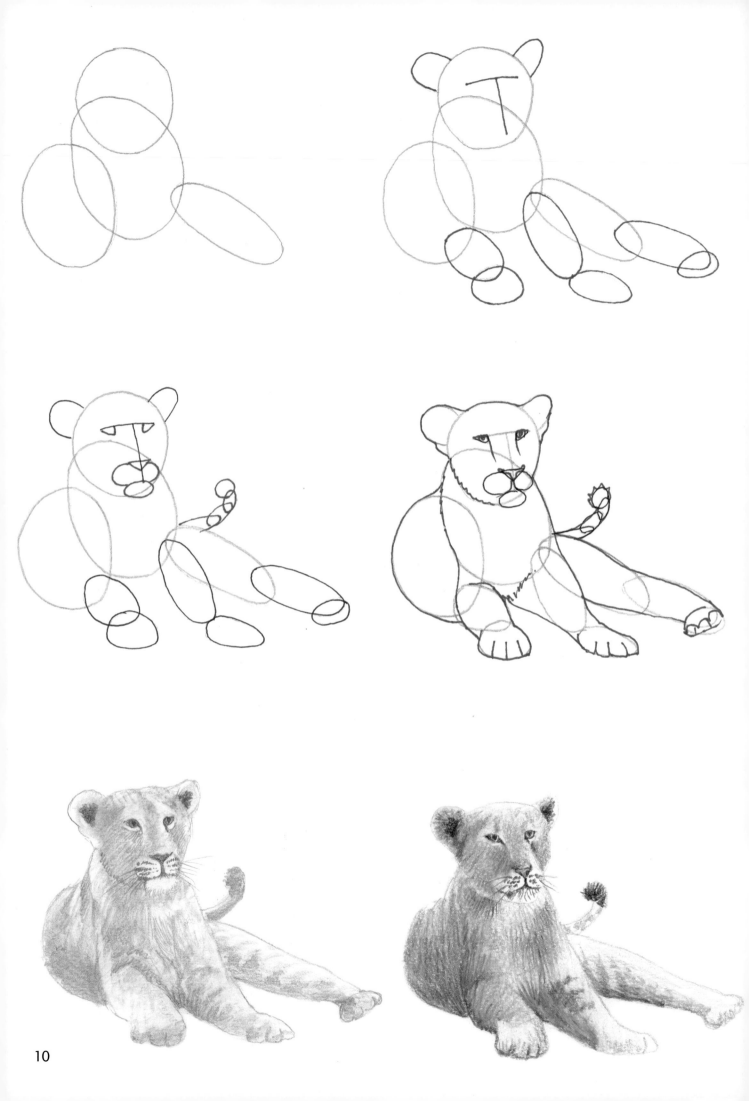

10

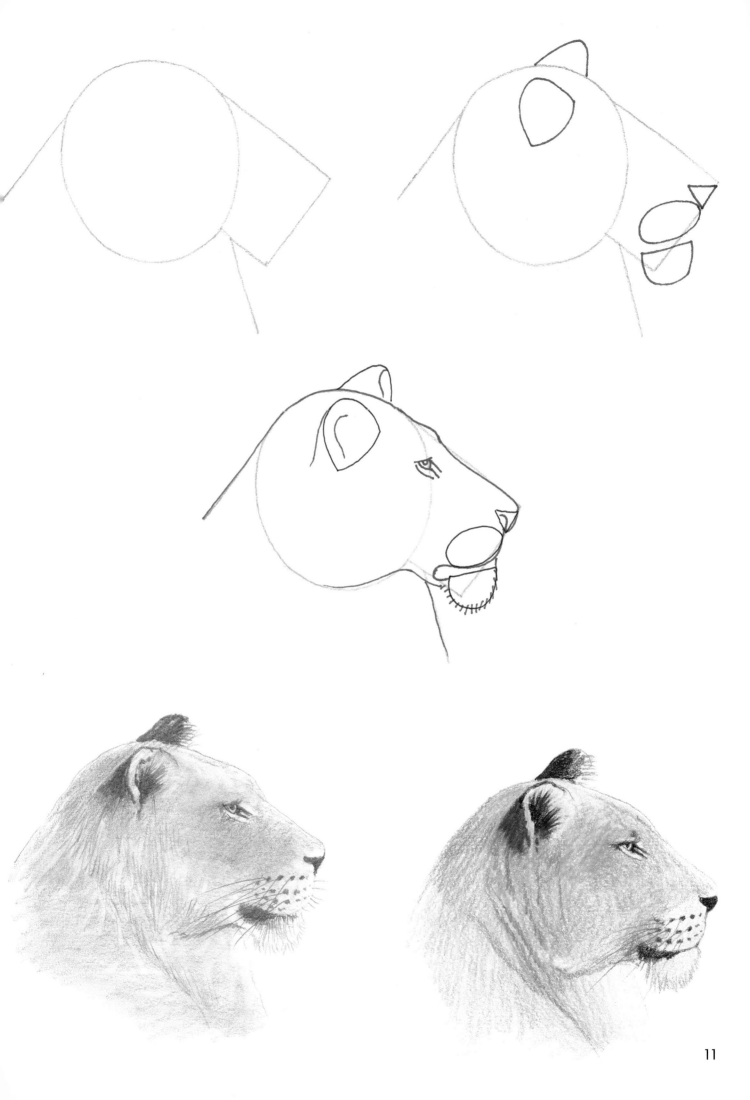

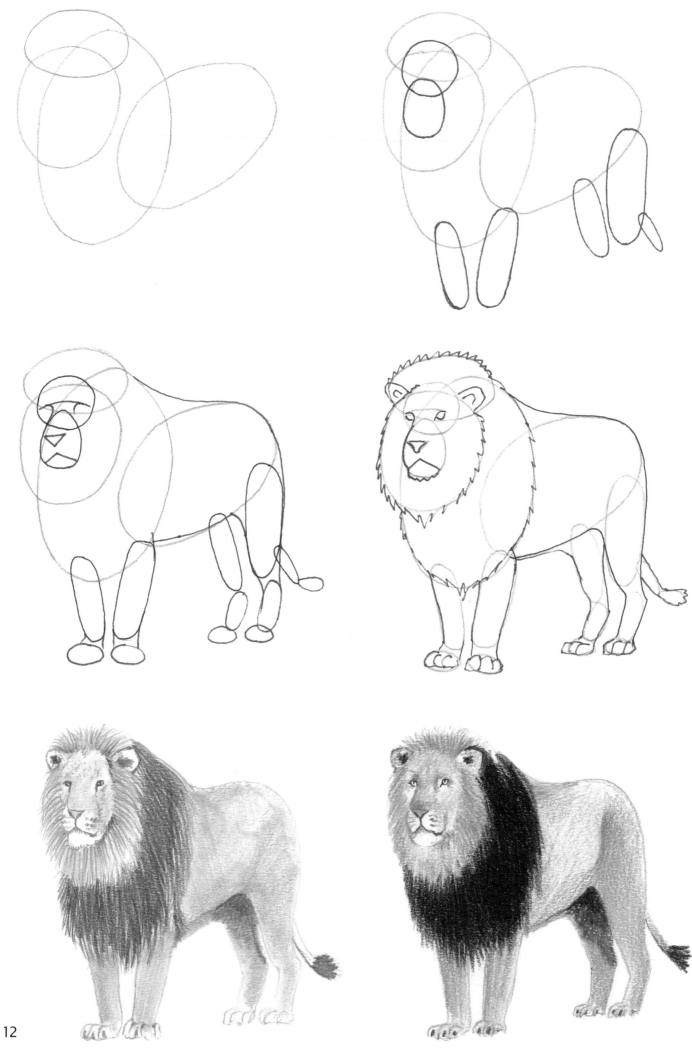

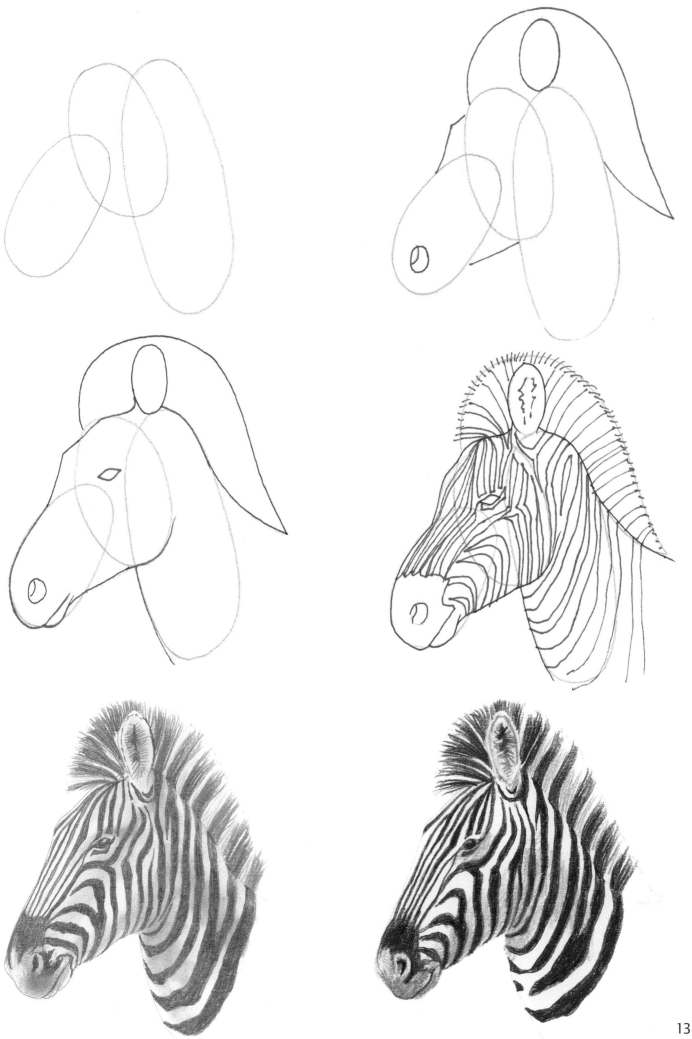

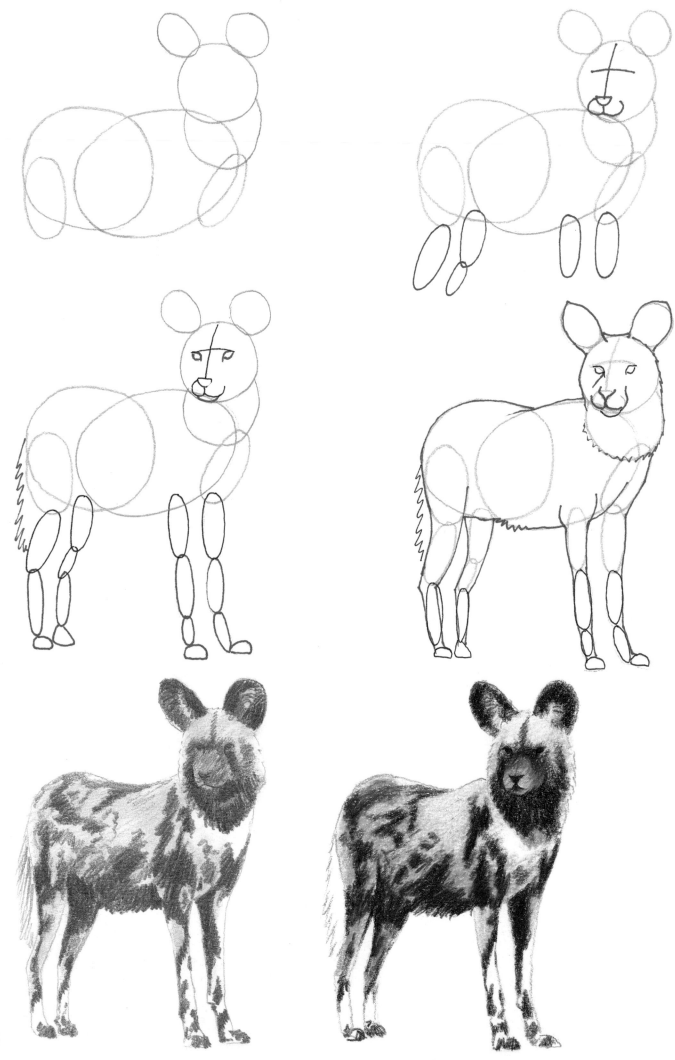

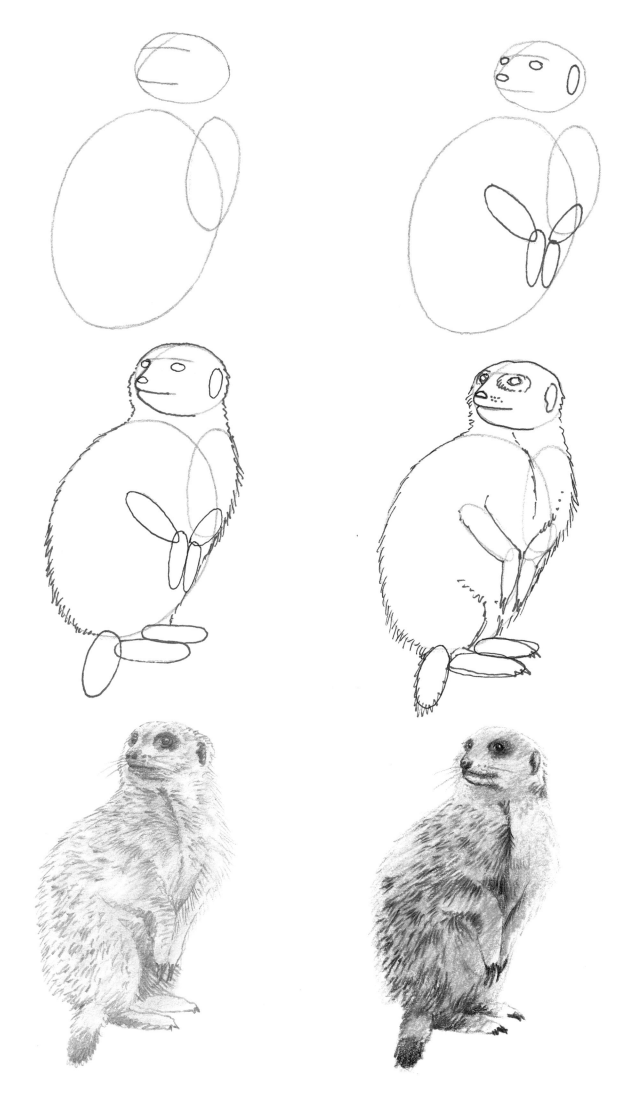

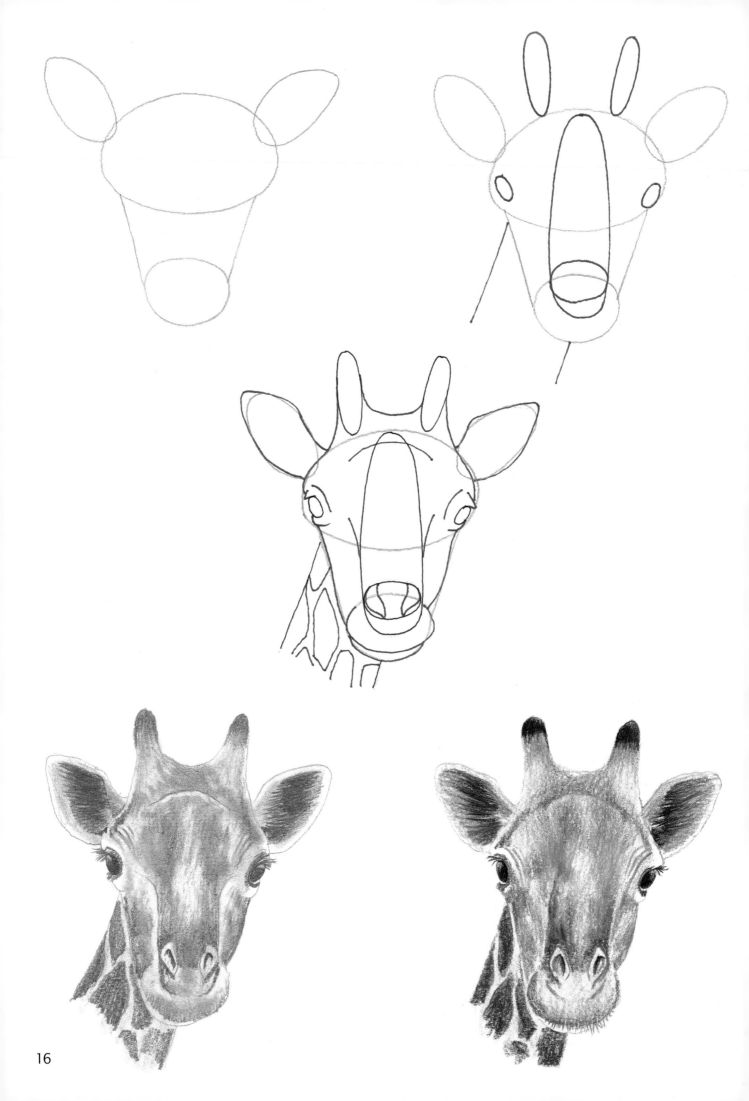

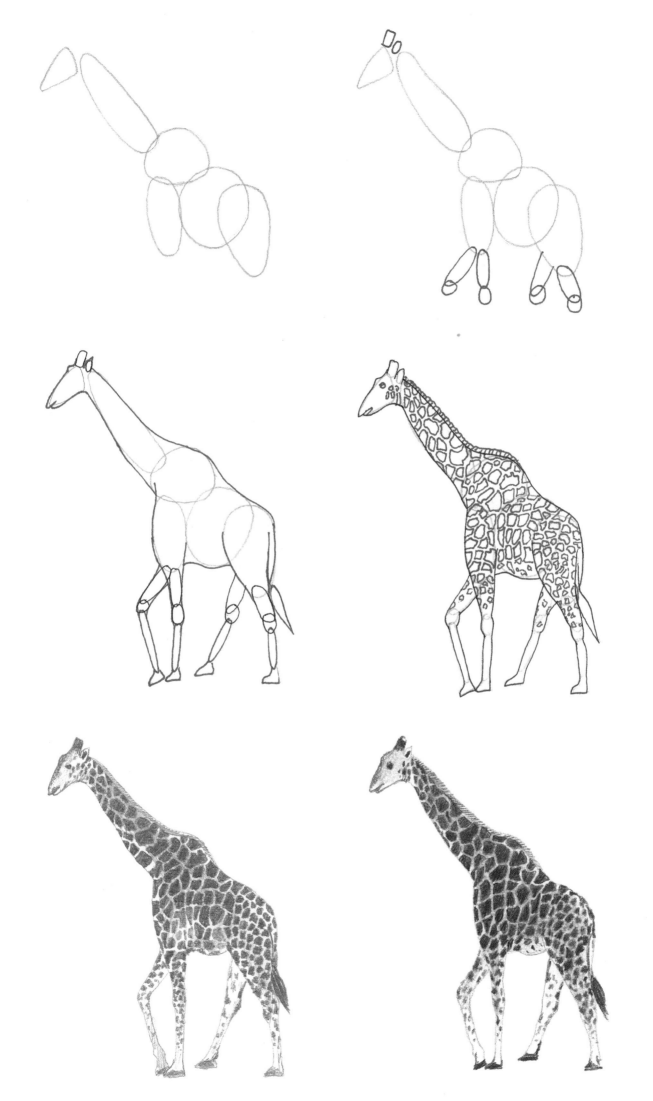

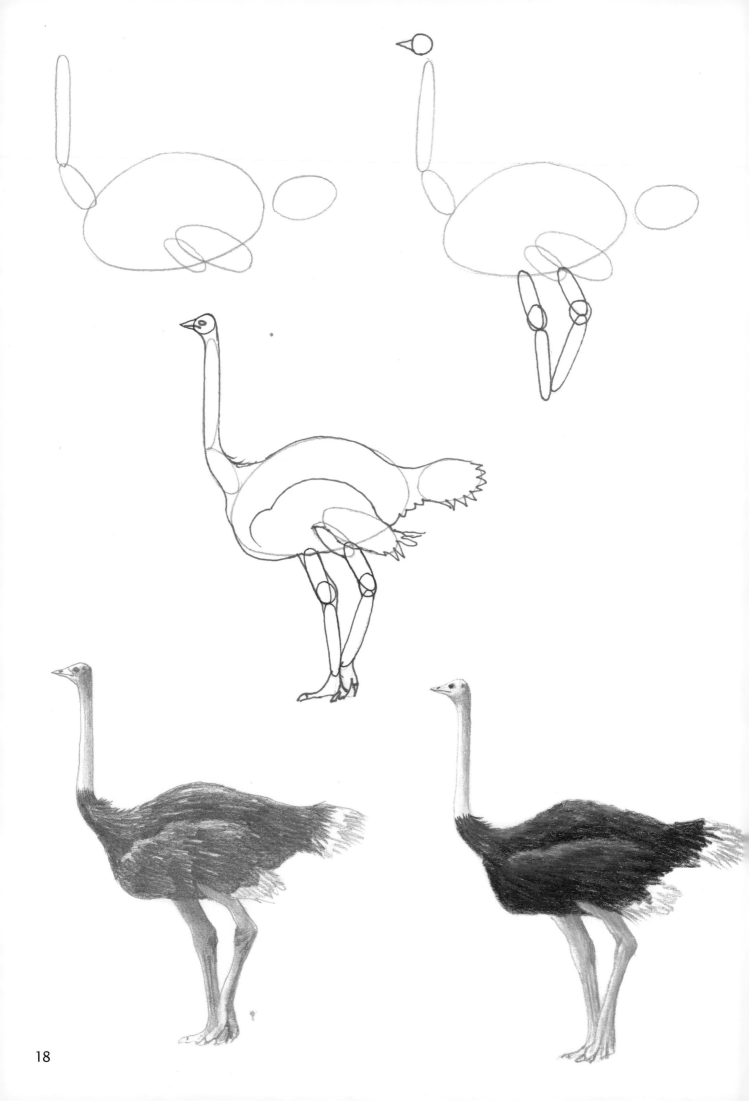

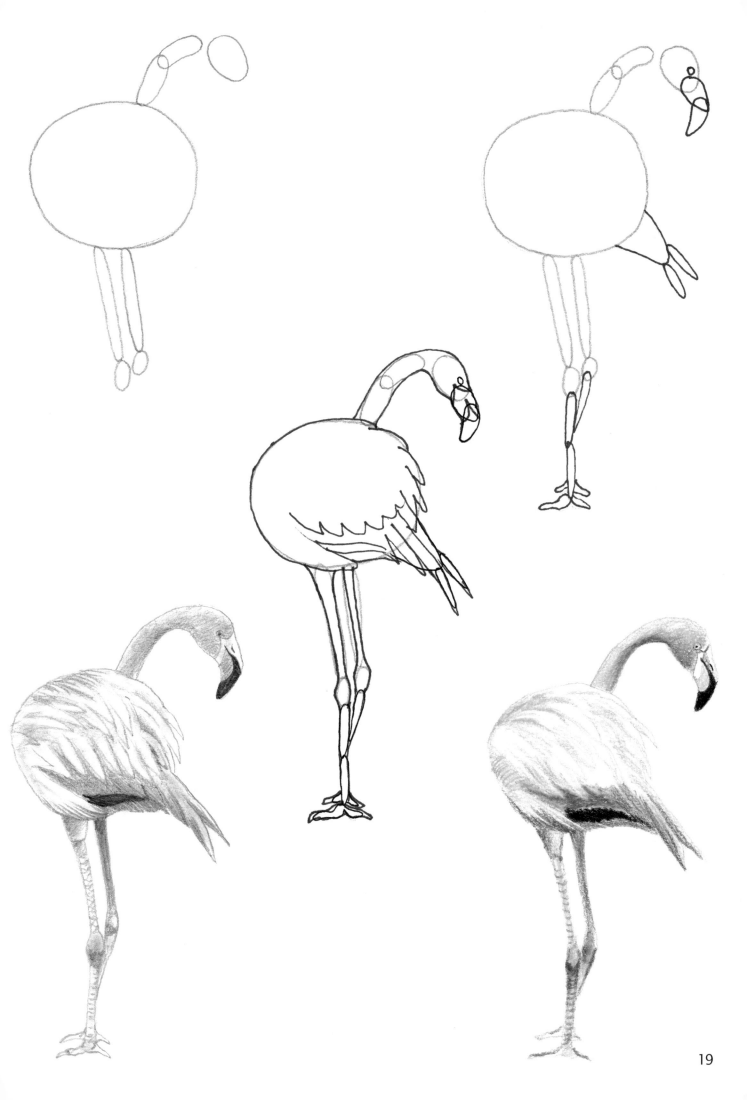

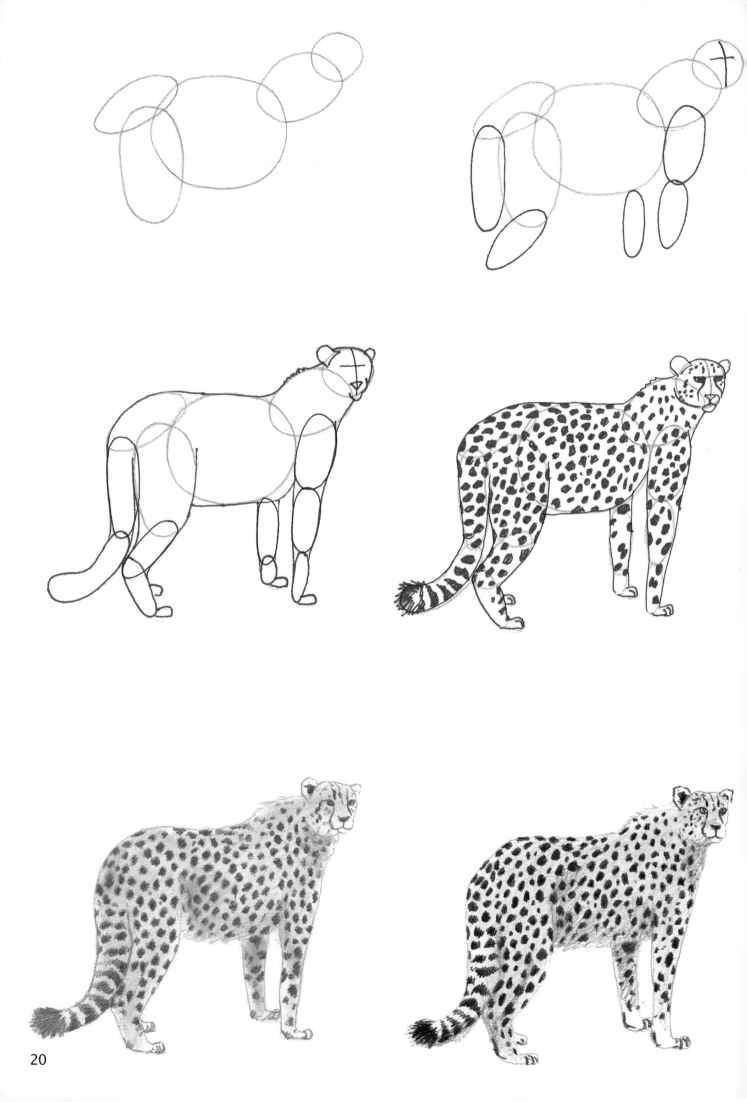

20

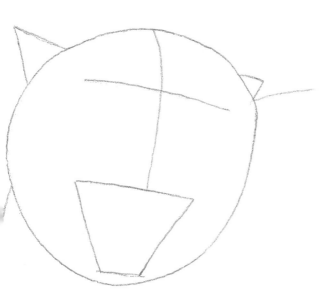
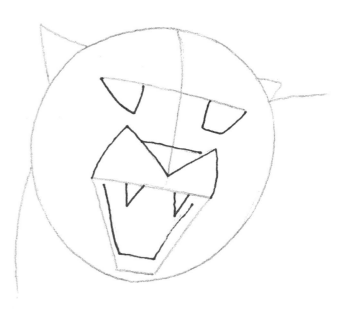
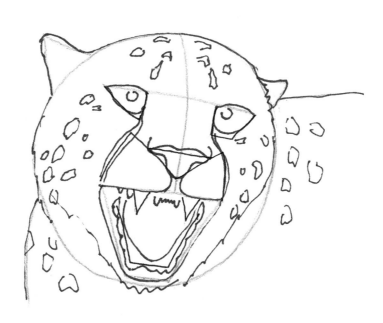
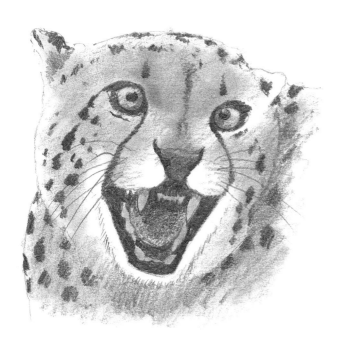
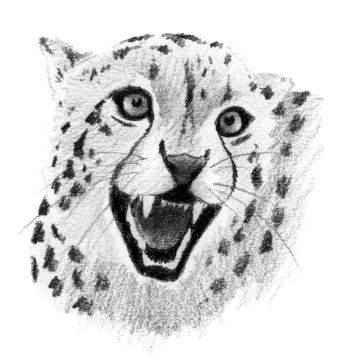

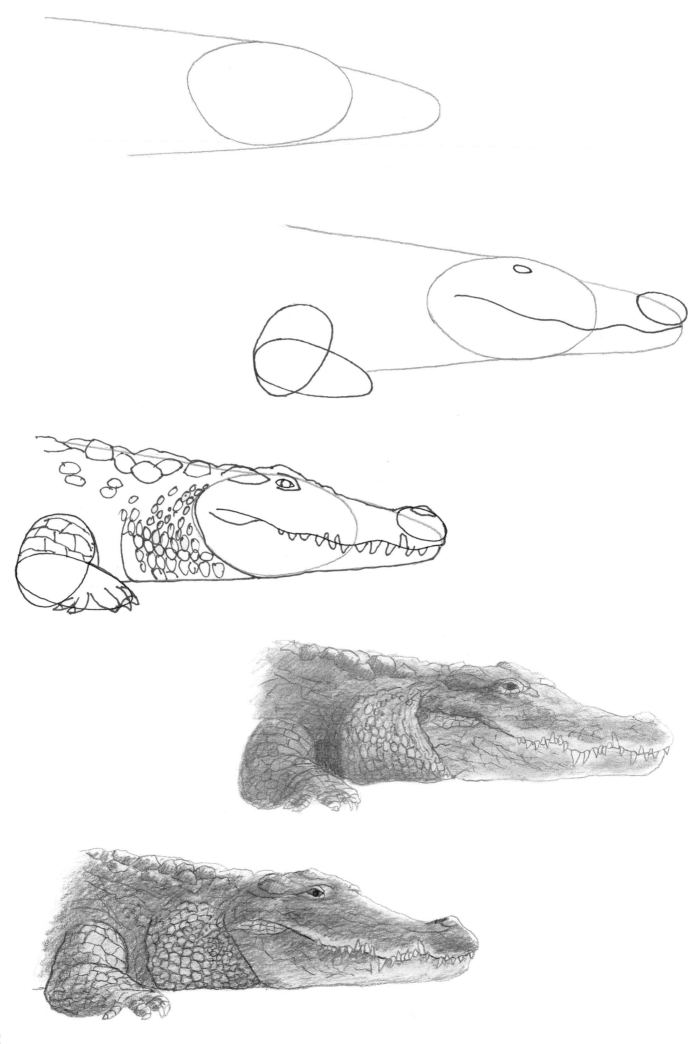

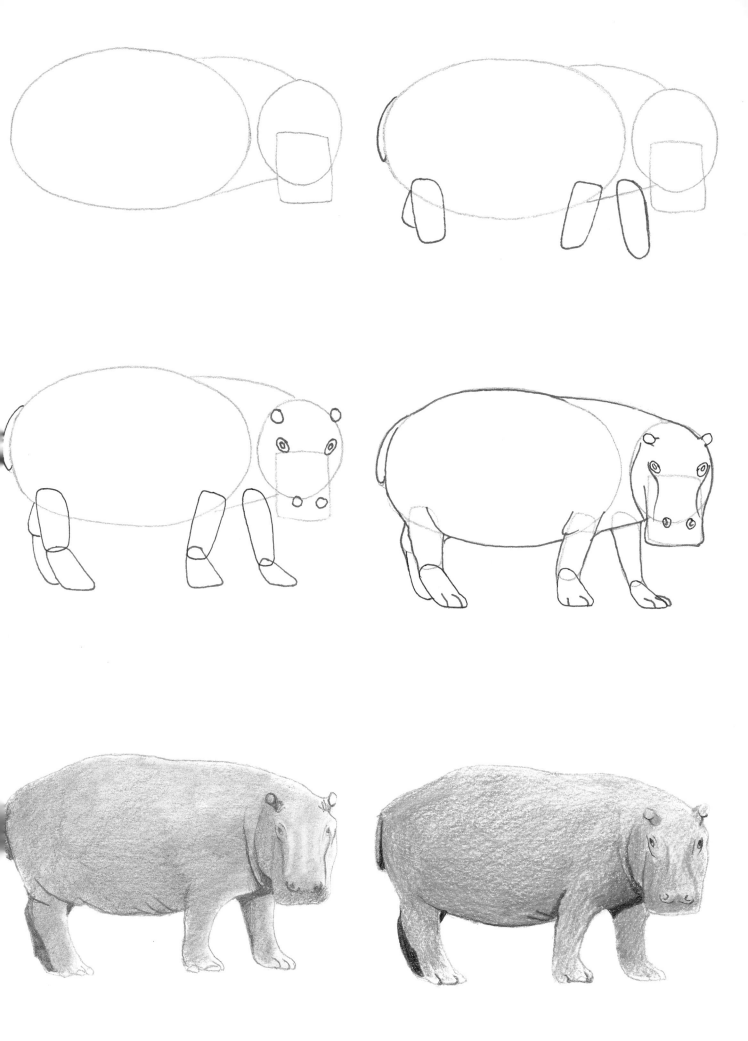

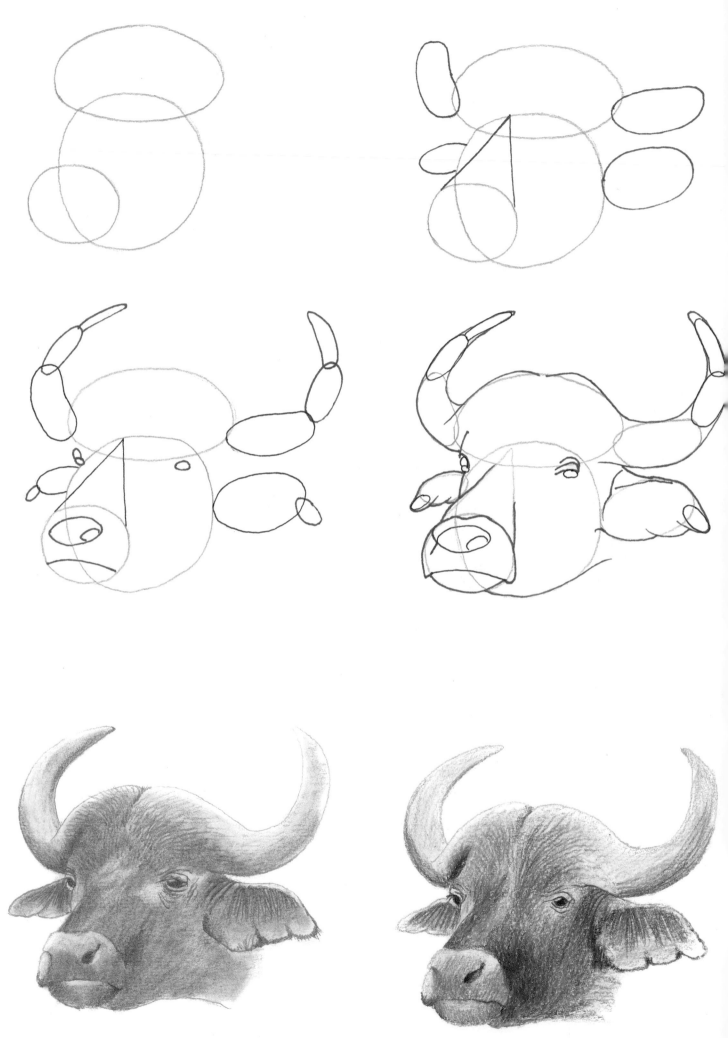

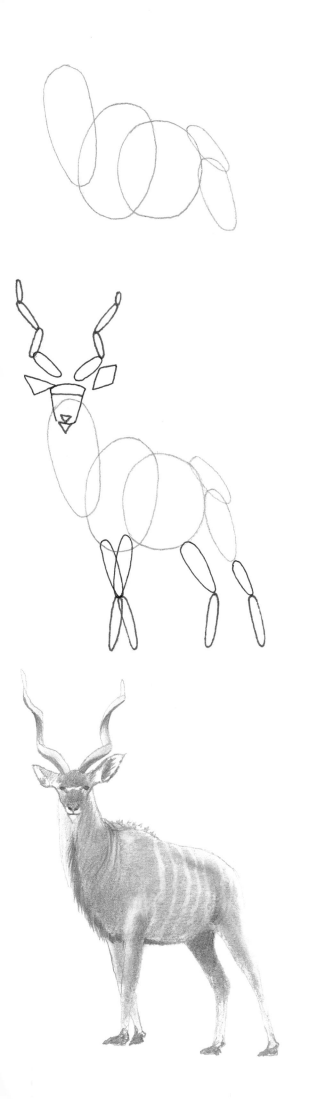
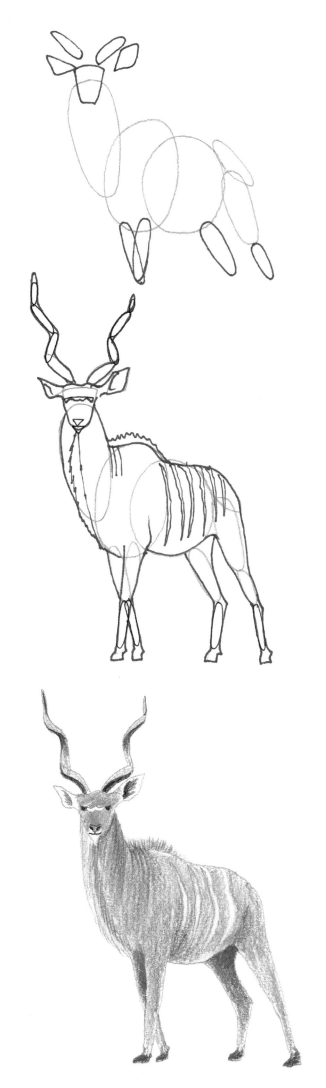

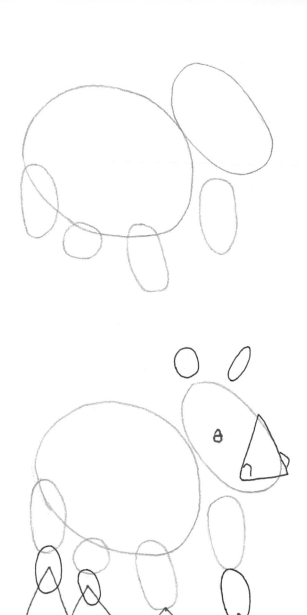

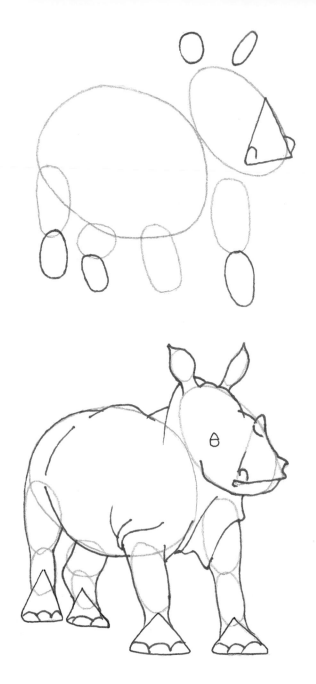

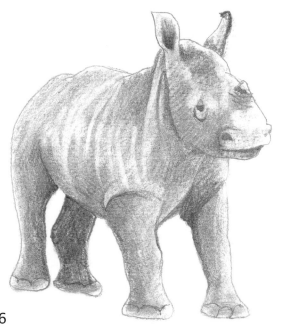

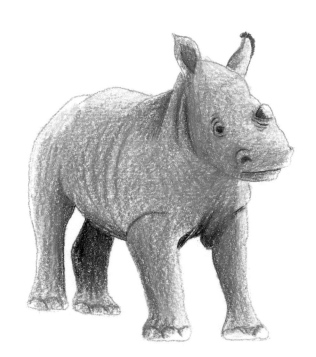

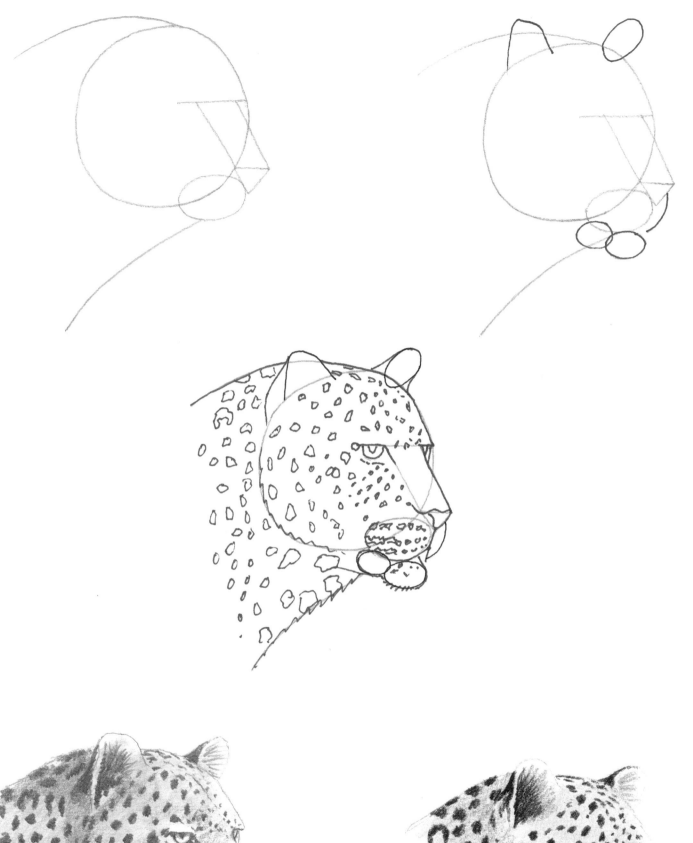

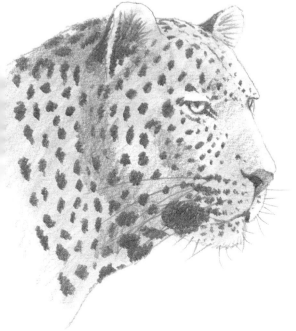

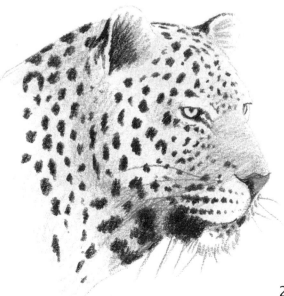

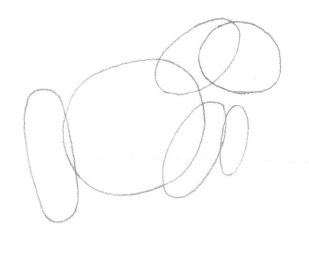
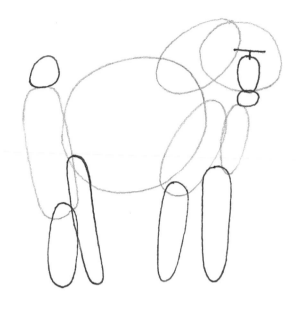
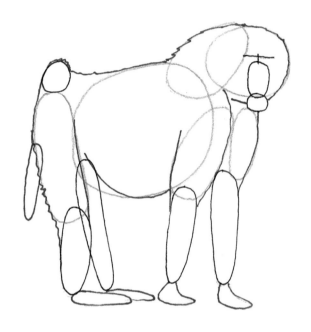
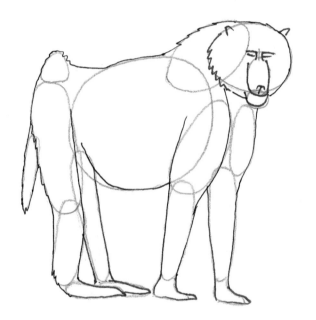
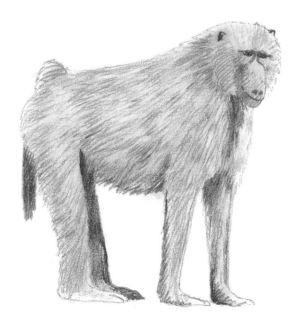
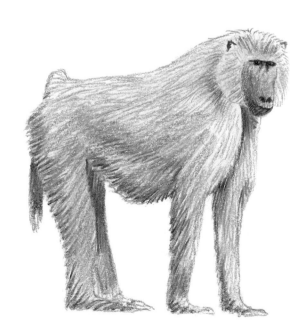

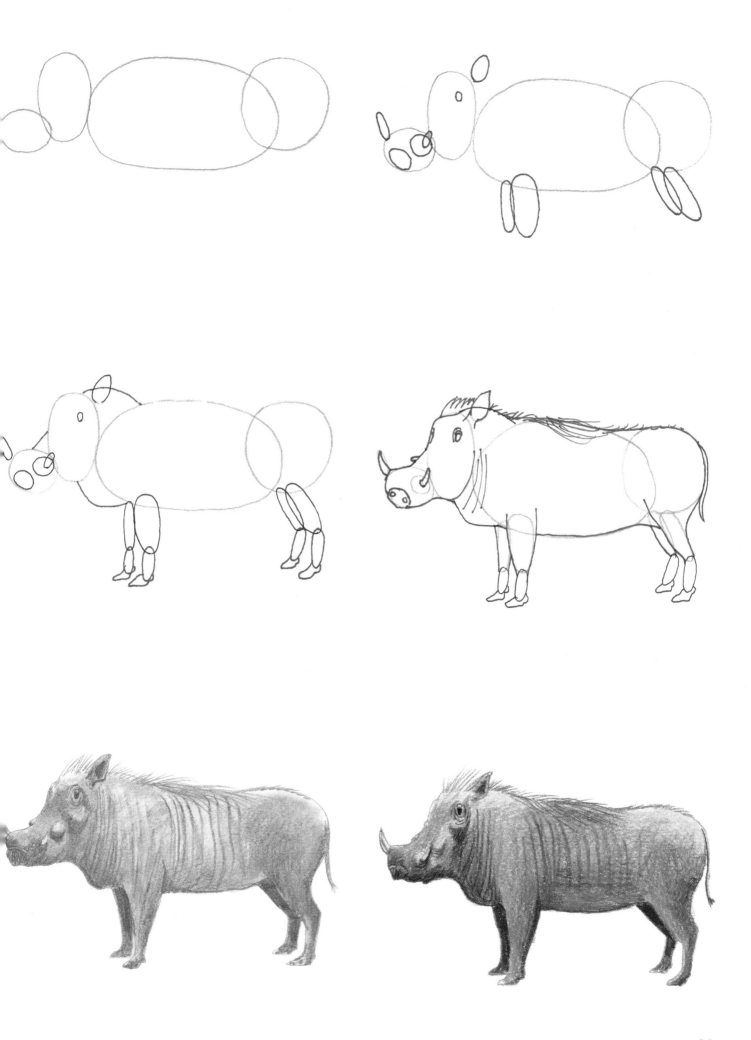

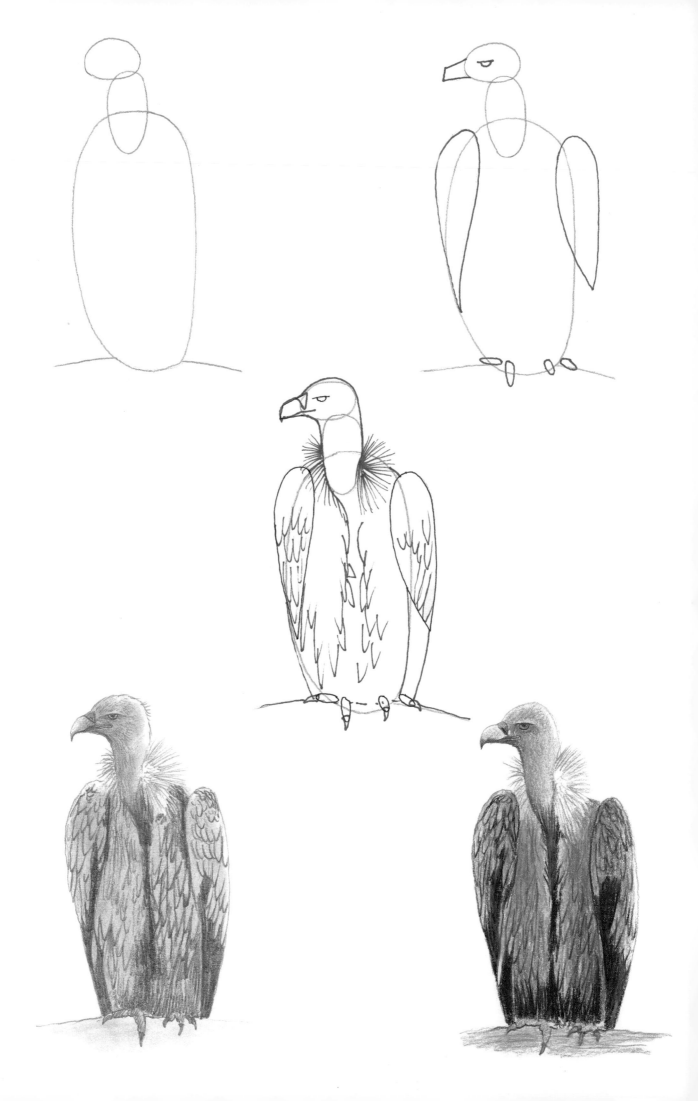

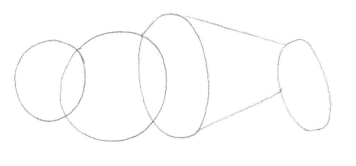

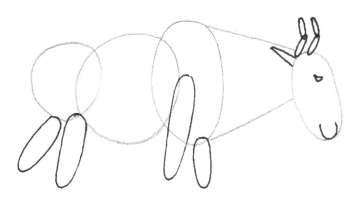

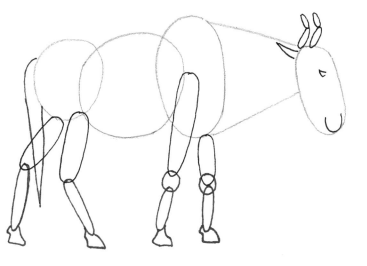

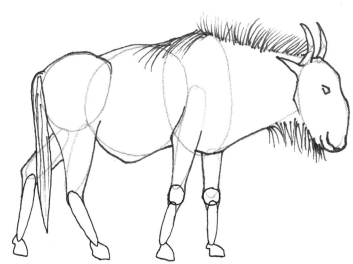

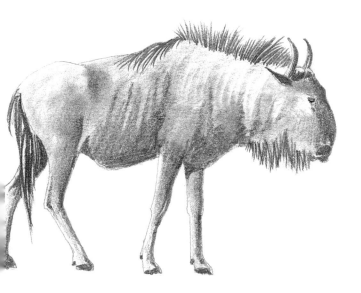

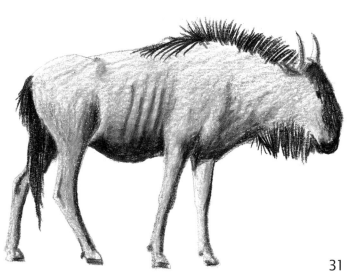

31

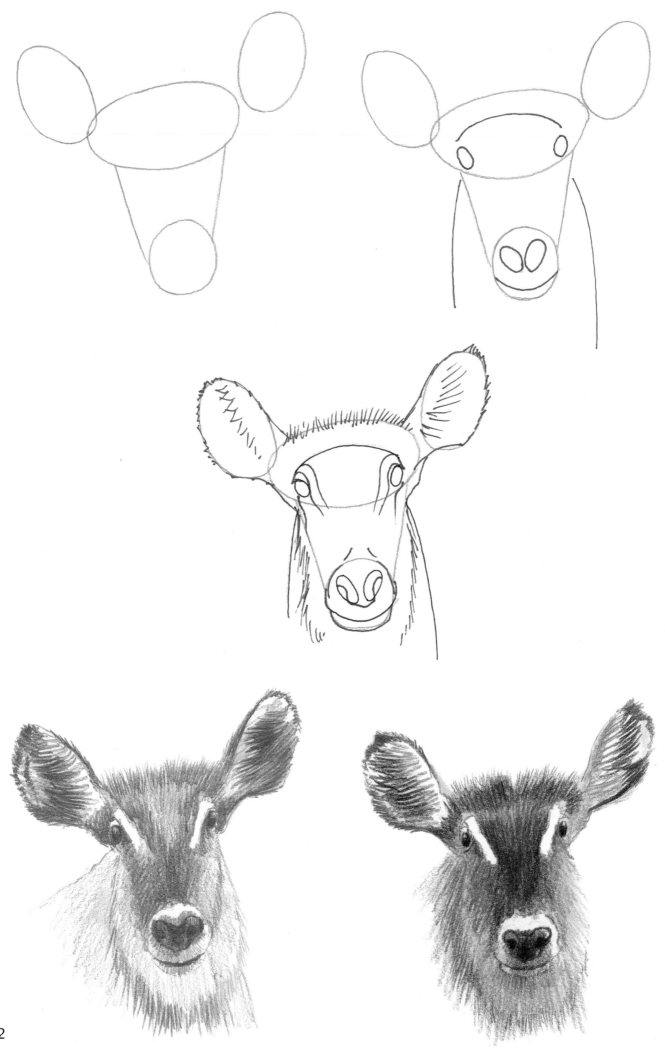